TALKING STATUES
OF LONDON

A Cutting Edge Press Original

Published in 2013 by Cutting Edge Press

www.cuttingedgepress.co.uk

Copyright © Julian Nieman

Julian Nieman has asserted his moral right to be identified as the author of this work under the terms of the 1988 Copyright Design and Patents Act.

Printed and bound by CPI Group (UK) Ltd.

ISBN: 978-1-908122-47-6
E-PUB ISBN: 978-1-908122-04-9

TALKING STATUES
OF LONDON

———◆———

Julian Nieman

Cutting
Edge
Press

To Sandy and Sam,
Adam and Jake, with love.

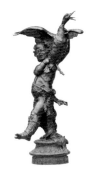

"To my friends, pictured within…"

This was the dedication by Sir Edward Elgar for his *Enigma Variations*, a musical work in which he expressed his view of the characters of some dear friends. I hope I may borrow his words because this book too is a friendly work.

The statues which stand in our cities are monuments, landmarks and old friends. They watch our busy lives and stay reliably there to greet us as we walk through their leafy squares or busy pavements. While we wait for traffic lights to change, they stand in the centre of roundabouts and do their best to inspire us with their portrayals of nobility or their allegories of virtue.

I have warm respect for the art and the crafts which went into the making of these statues. As well as the sculptor's work, public committees and decision-makers, stone-masons, foundrymen and conservators are necessary to establish each one of these public monuments.

Like family, the statues have varying degrees of quality. Some are great art and some are less so. Some express

themselves well and others are clumsy. Sometimes their messages become confused in the flourishes of art or in the passing of time. Like family, they are there and we live with them.

So it was not mockery which made me wonder what these statues of London were really saying, but a feeling of empathy. I have tried to listen and I hope you will enjoy the words I heard.

– JULIAN NIEMAN

P. S. Choosing the statues from so many was hard. In the end, I selected those whose voices I heard the clearest. They appear roughly in geographical order, beginning in the south-east of the capital at Greenwich, crossing the Thames into the City, on to the West End, into Kensington & Chelsea, up to Regent's Park and north to Finchley.

Yuri Gagarin (1934-1968)

On 12 April 1961, Soviet pilot and cosmonaut Yuri Gagarin became the first human to journey into outer space. Travelling at a speed of 27,400kph, he orbited the Earth in the spacecraft *Vostok 1* in a flight lasting 108 minutes. He was just 27.

To his anguish, Gagarin was never allowed into space again. He died seven years later when his MiG fighter jet crashed in mysterious circumstances during a training flight.

* * *

This zinc alloy sculpture by Anatoly Novikov is a copy of the 1984 original commissioned by the town of Lyubertsy, just outside Moscow, where Gagarin trained as a steel foundry worker. The sphere represents the Earth and the loop around it the trajectory taken by the space capsule.

Russian authorities rarely give permission for monuments to leave the country and, in Gagarin's 50th anniversary year, moving his statue out of Russia was unthinkable. But after many discussions, it was agreed that Roscosmos, the Russian Space Agency, could make an exhibition copy of the work. Moulds were taken from the original in September 2010, and the statue was made in Izhevsk, the town renowned for manufacturing the AK-47 assault rifle.

Following temporary residence in the Mall opposite the statue of Captain Cook, the sculpture was moved to its permanent home at the Royal Observatory. It was unveiled by the cosmonaut's daughter, Elena Gargarina, on 9 March 2013 to mark her father's anniversary.

SCULPTOR	Anatoly Novikov
INSTALLED	2013
LOCATION	Royal Observatory, Greenwich SE10
LATITUDE & LONGITUDE	51.476851, -0.000551

Full Stop, Optical

'Full Stop' refers to the punctuation mark. 'Optical' is the name of a typeface. Put the two together and the result is this giant, three-dimensional full stop by 'Young British Artist' Fiona Banner. The sculpture was made in plaster, worked by hand, then cast in bronze and coated in shiny black car paint to reflect the surrounding landscape.

* * *

Standing outside City Hall, offices to the Mayor of London, this sculpture is one of a set of five 'Full Stops' on the riverfront by Tower Bridge, each depicting a different typeface. In addition to Optical, these are Slipstream, Courier, Klang and Nuptial.

SCULPTOR	Fiona Banner (1966–)
INSTALLED	2004
LOCATION	West of City Hall, The Queen's Walk, SE1
LATITUDE & LONGITUDE	51.504879, -0.079158

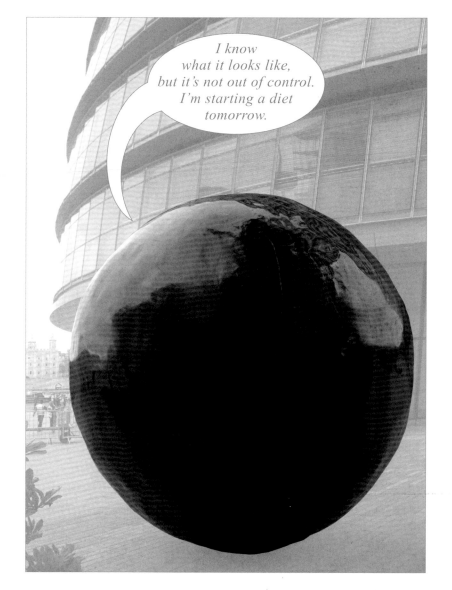

6

Queen Victoria (1819-1901)

Queen Victoria came to the throne in 1837 at the age of only 18. Her reign of 63 years and 216 days makes her Britain's longest-serving monarch (although Queen Elizabeth II is closing fast). She married her cousin, Albert of Saxe-Coburg and Gotha, in 1840 and enjoyed a deeply loving marriage during which she had nine children. Prince Albert's sudden death in 1862 left her devastated, and she wore black in mourning for the remaining 40 years of her life.

Queen Victoria survived at least seven assassination attempts between 1840 and 1882. Her courage in the face of these attacks greatly strengthened her popularity, although she received widespread criticism for retreating from public life after the death of her husband. However, she continued to be the figurehead of the British Empire as it expanded around the globe to include India, Singapore, Australia, Canada, Egypt and many parts of Africa.

Her face appeared on the world's first prepaid postage stamp, the Penny Black. She was also the first British monarch to travel by train, the first to use electric lights and a telephone, and the first to be photographed. The journal which she kept from the age of 13 encompasses 122 volumes. In 2008, a pair of her 50-inch waist bloomers fetched £4,500 at auction.

* * *

The first cast of the statue by Charles Birch was shipped to Udaipur in India in 1889. This one was unveiled by the Queen's cousin, the Duke of Cambridge, in 1896, three years after Birch's death.

SCULPTOR	Charles Bell Birch (1832-1893)
INSTALLED	1896
LOCATION	Approach to Blackfriars Bridge (north) EC4
LATITUDE & LONGITUDE	51.511213, -0.104426

Queen Anne (1665-1714)

The Protestant daughter of the Catholic King James II, Queen Anne reigned as Queen of England, Scotland, Ireland and France (although her claim to the latter was rather empty) from 1702 to 1714. She signed the Acts of Union (1707) that joined England and Scotland into a single, united kingdom named 'Great Britain'.

After marrying Prince George of Denmark in 1683, her 17 pregnancies yielded just one surviving child, Prince William, who died at the age of 11.

* * *

The original of this statue was created by leading English sculptor Francis Bird in association with Christopher Wren, the architect of St Paul's Cathedral. Marking the completion of the cathedral, it was unveiled on 7 July 1713 at a great thanksgiving service for the Peace of Utrecht, which had ended nearly 25 years of continuous war in Europe.

Having lost its nose, fingers, globe and sceptre to "lunatics and thieves", the statue had weathered so badly by 1882 that it was consigned to a scrapyard, where it was discovered by the writer Augustus Hare. He transported it to his home at Holmhurst St Mary's in East Sussex. It still stands there today.

Meanwhile, the task of making a replica was given to Richard Belt, who'd just won one of the longest libel trials in British legal history (43 days, 82 witnesses) after being accused of "fraudulent imposture" by a fellow sculptor. Belt completed the model for the statue but then resigned from the job, leaving Belgian sculptor Louis Auguste Malempré to finish it off.

SCULPTOR	Richard Belt (1854-1920) & L. A. Malempré (1820-1888)
INSTALLED	1886
LOCATION	St Paul's Cathedral, EC4
LATITUDE & LONGITUDE	51.513674, -0.099963

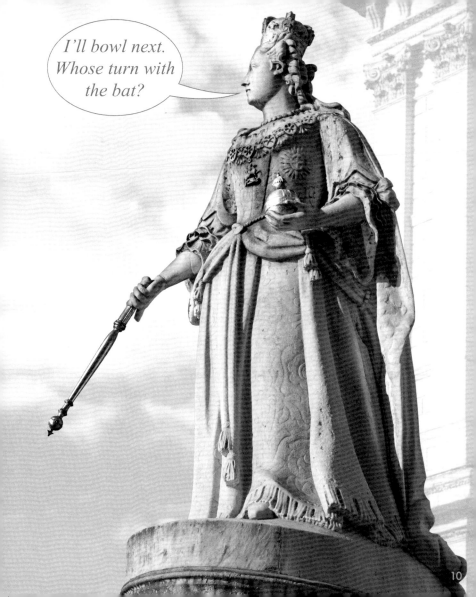

10

Thomas à Becket (1118-1170)

Born in Cheapside, London, Becket became Lord Chancellor in 1155 and soon forged a close friendship with King Henry II. Henry needed an ally at the head of the Church, and in 1162 he appointed his friend as Archbishop of Canterbury. Against all Henry's expectations, Thomas transformed himself from a pleasure-loving courtier into a serious cleric and, most crucially, transferred his loyalty to the Church. Disagreements with the King followed, and Becket fled into exile in France.

On his return in 1170, knights loyal to Henry murdered Becket on the steps at Canterbury Cathedral (although the King denied this had been his wish). Seen as a martyr, Becket was canonised two years later by Pope Alexander III.

* * *

This sculpture depicting Becket at the moment of his murder was made by Edward Bainbridge Copnall. He was born in Cape Town, South Africa, but moved to Horsham, Sussex, when he was young. In World War II he worked as a camouflage officer in the Middle East, building dummies as part of the military deception for Operation Crusader. Copnall was president of the Royal Society of British Sculptors from 1961 to 1966.

SCULPTOR	Bainbridge Copnall (1903-1973)
INSTALLED	1973
LOCATION	St Paul's Churchyard, St Paul's Cathedral, EC4
LATITUDE & LONGITUDE	51.513453, -0.097831

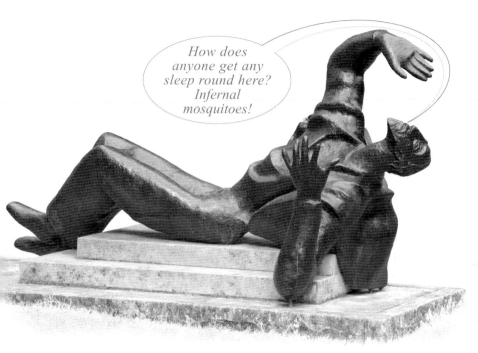

Paternoster

Paternoster is Latin for 'Our Father'. In the Bible, God is sometimes likened to a shepherd and sometimes referred to as a father.

Paternoster Square marks an area in London which was entirely flattened by bombing in World War II. It was redeveloped in the late 1960s as a complex of office blocks, which were unpopular and considered insensitive to the attraction of St Paul's Cathedral. The Square was demolished and replaced by 2003.

Sculpted by Dame Elizabeth Frink, the bronze 'Shepherd and Sheep' – or 'Paternoster' – was commissioned for the previous Paternoster Square complex in 1975, and then replaced on a new plinth following the redevelopment.

* * *

Born in Suffolk, sculptor Dame Elizabeth Frink studied at Guilford School of Art and Chelsea School of Art. Although she worked on paper too, she is best known for her bronze outdoor sculptures, of which there are many. Her style typically involved creating an original form by applying plaster to an armature, and then carving that with a chisel and rasp, producing a distinctive texture when cast.

SCULPTOR	Dame Elizabeth Frink (1930-1993)
INSTALLED	1975/2003
LOCATION	Paternoster Square, EC2
LATITUDE & LONGITUDE	51.514745, -0.099186

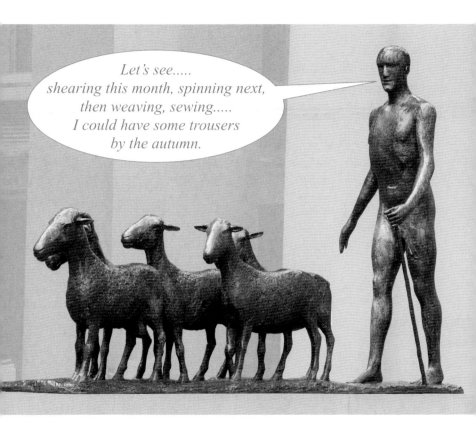

14

Beyond Tomorrow

Beyond Tomorrow was bought and donated by Lord Blackford, a former Deputy Speaker in the House of Commons. One of his friends suggested the title for the piece because the two figures seem to be looking ahead – perhaps into the future.

* * *

The sculptor, Karin Jonzen, was born in London to Swedish parents. She studied art at the Slade School and won the Prix de Rome when she was just 24. Renowned for her *joie de vivre* despite several matrimonial disasters, she was still riding a motor scooter at the age of 80. Her obituary in *The Independent* quoted two sentences as typical of her: "So far every ride has been a joy ride" and "I wanted to find out something of what life is all about."

SCULPTOR	Karin Jonzen (1914-1998)
INSTALLED	1972
LOCATION	Guildhall Plaza, EC2
LATITUDE & LONGITUDE	51.5160727, -0.0920992

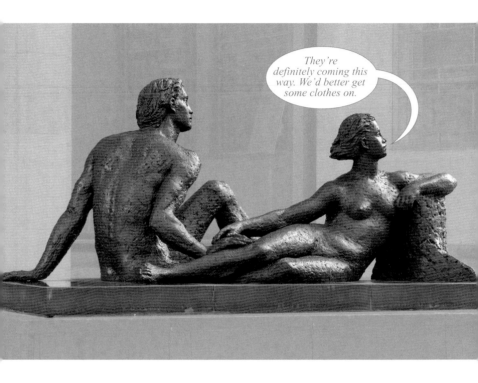

16

Sir Rowland Hill (1795-1879)

Inventor of the postage stamp, postal reformer and education reformer, Rowland Hill was already teaching in his father's school by the age of 12. He later set up his own school – with a science laboratory, a swimming pool and forced air heating – which rapidly set a precedent for liberal education based on kindness and moral influence, rather than caning and fear.

Hill began to consider postal reform in 1835. Expensive and slow, the postal system had become inadequate for the needs of an expanding industrial nation. At that time, letters were normally paid for by the recipient, not the sender. When Hill heard the story of a young woman who was too poor to redeem a letter sent by her fiancé, he drew up a report for the Chancellor of the Exchequer calling for low and uniform charges prepaid by the sender. The Penny Post was introduced in 1840.

Hill later became secretary to the Postmaster General and then Secretary to the Post Office. He died in Hampstead and is buried in Westminster Abbey.

* * *

Hill's sculptor, Edward Onslow Ford, was born in Islington but finished his education abroad, studying in Antwerp and Munich. He completed many monuments and busts during a successful career and was very popular amongst his colleagues and students, who raised money for a memorial to him when he died unexpectedly, at the age of 49. This memorial stands at the junction of Grove End Road and Abbey Road in St John's Wood, London.

SCULPTOR	Edward Onslow Ford (1852-1901)
INSTALLED	1923
LOCATION	King Edward Street, EC1
LATITUDE & LONGITUDE	51.516087, -0.098653

Prince Albert (1819-1861)

Prince Albert of Saxe-Coburg and Gotha (the name of Britain's Royal Family was changed to the less Germanic 'Windsor' at the start of World War I) was the much beloved husband of Queen Victoria. As she once put it: "He possesses every quality that could be desired to render me perfectly happy."

Marriage to Queen Victoria, however, was not without its drawbacks. As he once wrote: "I am very happy and contented; but the difficulty in filling my place with the proper dignity is that I am only the husband, not the master in the house." Despite playing second fiddle, he remained an energetic and enlightened man, promoting education and trade, and campaigning against slavery until his death at the age of 42 from typhoid fever (or, modern doctors suspect, Crohn's disease).

The claim that Prince Albert invented the genital piercing that shares his name is almost certainly false.

* * *

Unveiled in 1874, this statue was nicknamed 'The Politest Statue in London' because Prince Albert can be seen tipping his hat to all, but in reality the gesture was directed at the City of London. Presented by Charles Oppenheim, founder of the De Beers diamond company, the monument was recently blamed as a contributor to traffic accidents. The seated figure beneath the horse is an allegory of Peace, bearing a laurel crown and a palm in her left hand and a cornucopia in her right.

The statue, which cost £2,000 and marked the peak of sculptor Charles Bacon's career, was ill-received. As *The Art Journal* remarked at the time: "On the principle that one must not too narrowly examine a gift horse, we abjure criticism."

SCULPTOR	Charles Bacon (1822-1884)
INSTALLED	1874
LOCATION	Holborn Circus, EC1
LATITUDE & LONGITUDE	51.517756, -0.107606

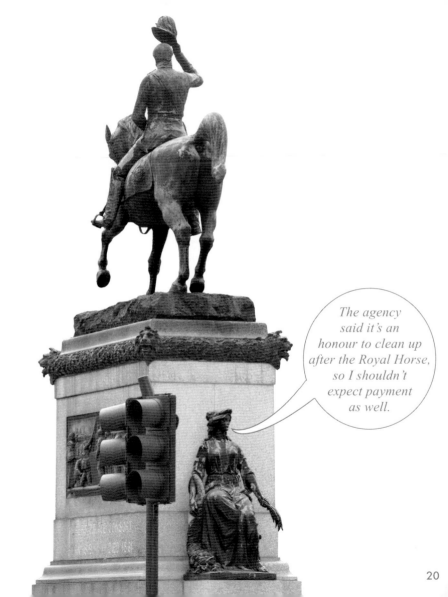

20

Courage

This is one of the four allegorical groups that surround the column on which stands the figure of William Ewart Gladstone (1809-1898). Courage, Brotherhood, Aspiration and Education represented his strengths and priorities.

Gladstone was a Liberal statesman who served as Prime Minister four times during a parliamentary career of 64 years. He entered Parliament in 1833 and in his maiden speech defended his father (who amongst other enterprises owned a West Indian sugar plantation) against allegations that he mistreated the slaves he owned.

Winston Churchill later claimed Gladstone was Britain's greatest Prime Minister, but Queen Victoria thought otherwise, once remarking that she would "sooner abdicate than send for or have anything to do with that half-mad fire-brand who would soon ruin everything and be a dictator."

* * *

The sculpture is by Sir William 'Hamo' Thornycroft, the sixth of the seven children born to London-based sculptors Thomas and Mary Thornycroft. Despite initial resistance from his father, Hamo trained in the family studio before enrolling at the Royal Academy Schools in 1869. After winning the Gold Medal in 1875, he went on to receive numerous commissions for public monuments throughout Britain and the Empire.

SCULPTOR	Sir (William) Hamo Thornycroft (1850-1925)
INSTALLED	1905
LOCATION	Aldwych, WC2
LATITUDE & LONGITUDE	51.513046, -0.114274

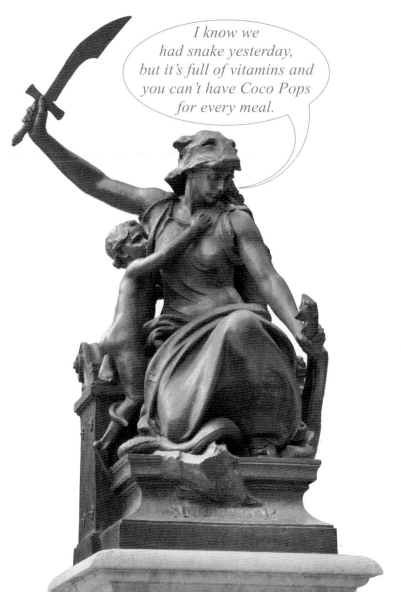

Dolphin Lamp Post

Some claim that the iconic lamp posts lining the Victoria & Albert Embankment actually depict sturgeons rather than dolphins. In any event, they were designed by George Vulliamy, superintending architect to the Metropolitan Board of Works, based on examples he had seen on the Neptune Fountain in the Piazza del Popolo in Rome. He also designed the pedestal and sphinxes for Cleopatra's Needle.

Since their introduction in the 1870s, further castings of the Dolphin lamps have been added to stretches of the Thames-side walks, including Southbank in the 1960s and the Queen's Jubilee Walkway of 1977.

* * *

Although the lamp posts originally used gas, Charles Dickens noted in his *Dictionary of London* that they were adapted to electricity in 1878 as part of the capital's first major experiment with this new power source. Ironically, the company generating the electricity went bankrupt in 1884 and the lamps reverted to gas for a period.

SCULPTOR	George John Vulliamy (1817-1886)
INSTALLED	1870 onwards
LOCATION	Victoria & Albert Embankment
LATITUDE & LONGITUDE	Not applicable

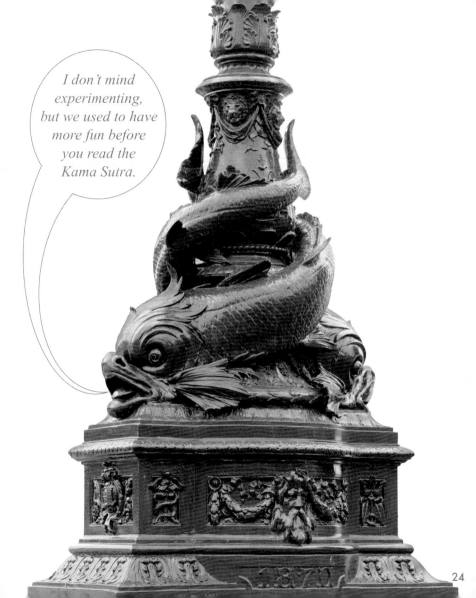

24

Nelson Mandela

Nelson Rolihlahla Mandela was born in Transkei, South Africa in 1918. Having qualified as a lawyer in 1942, he joined the African National Congress (ANC) in 1944 to resist the ruling National Party's racist apartheid policies.

After the ANC was banned in 1960, Mandela argued for the formation of a military wing within the ANC. He was tried for sabotage in 1962 and imprisoned on Robben Island. Confined to a small cell, the floor his bed, a bucket for a toilet, he was allowed only one visitor and one letter a year. He did not taste freedom again until 1990.

In 1993, he was awarded the Nobel Peace Prize, jointly with F.W. de Klerk, Prime Minister of South Africa, after the two of them had negotiated a peaceful route to democracy and inclusion. In 1994, Mandela became the first black President of South Africa in the country's first fully representative democratic election.

* * *

In 1962, during his first visit to London, Mandela half-joked with fellow ANC activist Oliver Tambo that a statue of a black man would one day stand alongside the likes of Abraham Lincoln and Benjamin Disraeli in Parliament Square. Over 40 years later, at the age of 89, Mandela returned to London for the unveiling of this statue by Ian Walters, himself a committed defender of human rights who worked with the ANC during the 1970s. Walters cast the statue in clay but died before it was cast in bronze, and so never witnessed its joyous reception.

SCULPTOR	Ian Walters (1930-2006)
INSTALLED	2006
LOCATION	Parliament Square, Westminster, SW1
LATITUDE & LONGITUDE	51.500498, -0.127417

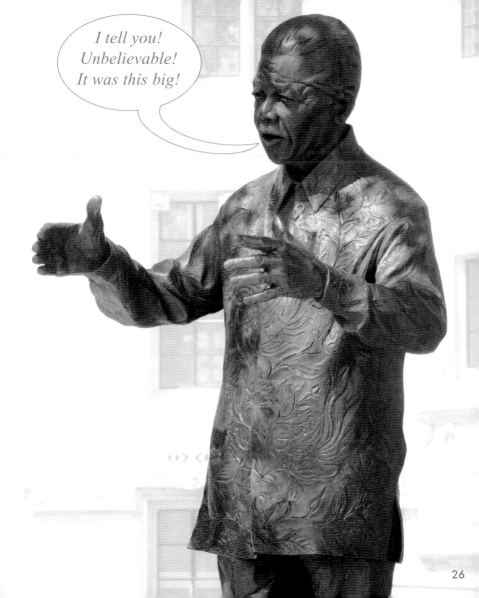

26

David Lloyd George (1863-1945)

Lloyd George was born in Manchester to Welsh parents. The family soon returned to Wales, where he was brought up as a Welsh speaker and also established his lifelong reputation as a charismatic orator. Having trained as a lawyer, he became the youngest member of the House of Commons in 1890 when he was elected to Parliament at the age of 27.

He was appointed as a cabinet minister in 1906 by the Liberal Prime Minister Sir Henry Campbell-Bannerman, and subsequently held several cabinet posts before becoming Prime Minister in 1916. Guiding the country through the trauma of World War I, he held power until 1922. In all, he was an MP for 55 years.

A great social reformer, his political inclinations were for the common man. He was largely responsible for the introduction of old age pensions, unemployment benefit and state support for the sick and infirm.

Unhappily married, Lloyd George led something of a double life. As an envious male aide once put it, "Women are always after him, and he after them." His private secretary Frances Stevenson, with whom he had a long-standing affair and later married, summed up his magnetic presence when recalling the first time she heard him speak: "I fell under the sway of his silver voice and his electric personality. I felt myself drawn in some mysterious way into his orbit."

* * *

Standing on a plinth of slate from Penrhyn Quarry in North Wales, this 8-foot, bronze statue was unveiled in 2007 by HRH The Prince of Wales.

SCULPTOR	Professor Glynn Williams (1939–)
INSTALLED	2007
LOCATION	Parliament Square, Westminster, SW1
LATITUDE & LONGITUDE	51.500863, -0.12667

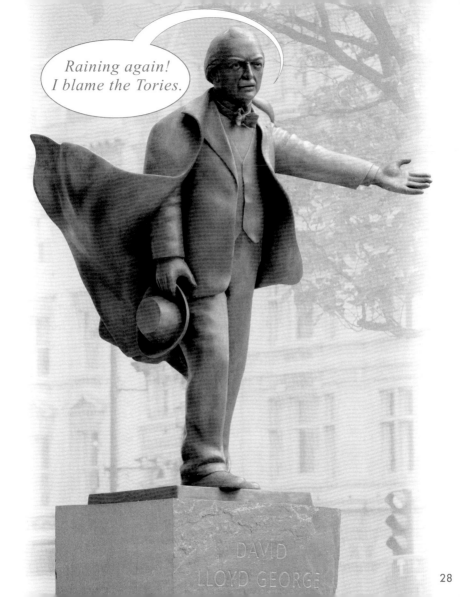

28

Bill Slim (1891-1970)

Or more precisely… Field Marshal William Joseph Slim, 1st Viscount Slim, KG GCB GCMG GCVO GBE DSO MC KStJ.

William 'Bill' Slim fought in both World Wars and was wounded in action three times. During World War II he led the 14th Army – the so-called 'forgotten army' – in the Burma Campaign. From 1953 to 1959 he was Governor-General of Australia, where he was regarded as an authentic war hero.

A firm and charismatic leader who earned the trust and respect of those he commanded, Slim summed up his battle philosophy as follows: "There is only one principle of war and that's this. Hit the other fellow, as quickly as you can, as hard as you can, where it hurts him most, when he ain't lookin'."

* * *

This statue was sculpted by Ivor Roberts-Jones, himself a survivor of the military campaign in Burma. Responsible for the magisterial statue of Sir Winston Churchill in Parliament Square, he was also a highly accomplished portrait painter, with Augustus John and Rupert Brooke among his subjects. A significant sculptor of wild animals, his numerous depictions of the blind and visually impaired represented a lifelong fascination.

SCULPTOR	Ivor Roberts-Jones (1913-1996)
INSTALLED	1990
LOCATION	Ministry of Defence, Whitehall, SW1
LATITUDE & LONGITUDE	51.50377300, -0.12616900

It was a tough battle, but I got to the bar and I came away with two bottles.

Abraham Lincoln (1809-1865)

Lincoln was the 16th President of the United States, serving from 1861 until his assassination in 1865. He guided the country through the crisis of civil war, preserved the Union, abolished slavery and paved the way for Daniel Day-Lewis to win a record-breaking third lead actor Oscar for his role in Spielberg's *Lincoln*.

* * *

This statue is a replica of a work by the American sculptor Augustus Saint-Gaudens. The original stands in Lincoln Park, Chicago.

The presentation of the replica was set to coincide with the centenary of the Treaty of Ghent (1814) – which ended the war between the United States and the United Kingdom – and the completion of 100 years of peace among English-speaking peoples. World War I delayed the plan.

Although the distinguished sculptor Sir James Frampton called Saint-Gaudens' work "perhaps the most beautiful monument in America", the US committee decided to send another statue of Lincoln by the sculptor George Barnard. Lincoln's son, Robert, insisted that presenting Barnard's statue to London "would be an international calamity", but in the end, both works came to Britain. Manchester got the Barnard version, while Saint-Gaudens' went to Parliament Square, as originally intended.

SCULPTOR	Augustus Saint-Gaudens (1848-1907)
INSTALLED	1920
LOCATION	Parliament Square, Westminster, SW1
LATITUDE & LONGITUDE	51.500849, -0.127887

32

George Washington (1732-1799)

One of the Founding Fathers of the United States of America, George Washington served as the Commander-in-Chief of the Continental Army during the American Revolutionary War and later as the new republic's first President (1789-1797). He presided over the convention which drew up the US Constitution. Both the country's capital city and one of its 50 states are named after him.

* * *

This is a bronze replica of the marble statue made by Jean-Antoine Houdon in 1784. The most famous sculptor in France, Houdon travelled to America with three assistants and stayed at Washington's home for several weeks, taking detailed measurements of Washington and making a life mask.

When the replica came to the National Gallery in 1921, the authorities sent a ton of Virginian soil for the statue to stand upon, in strict observance of Washington's vow to "never again set foot on English soil".

The statue depicts Washington wearing military uniform, with his cloak draped over a 'fasces', once a Roman symbol of authority and later a symbol for the Fascists. It consisted of a bundle of wooden rods, sometimes including an axe with its blade emerging. In this case, there are 13 rods representing the original 13 colonies, interspersed with arrows.

SCULPTOR	Jean-Antoine Houdon (1741-1828)
INSTALLED	1920
LOCATION	East lawn of National Gallery, Trafalgar Square, WC2
LATITUDE & LONGITUDE	51.508452, -0.127607

34

Mermaid

The centrepiece of the East Fountain in Trafalgar Square, the 'Mermaid' was designed by the Scottish sculptor William McMillan (*see also pp 79-80*), who died aged 90 after a street robbery and assault left him badly injured. His many works include the statue of Turner on the staircase in the Royal Academy and the golden 'Lightning Conductor' on top of Kensington Town Hall.

* * *

Trafalgar Square was originally going to be called King William IV Square, but public enthusiasm in response to Nelson's victory over Napoleon at the Battle of Trafalgar (1805) caused a change of plan. Although opposed to having Nelson's column there, architect Sir Charles Barry completed the square in its first form in 1845, designing the fountains not only for aesthetic appeal but also as a means of interrupting crowd movements and avoiding riotous gatherings.

The fountains were remodelled by Sir Edwin Lutyens in 1939, and the originals sent to Canada as a gift. The East Fountain forms part of the memorial to Admiral Beatty (1871-1936), who commanded the 1st Battlecruiser Squadron at the Battle of Jutland in 1916.

The lights illuminating the Mermaid at night were recently replaced by multi-coloured LEDs submerged in the water. The new system has cut the carbon footprint of the fountains by 90%. The old bulbs failed consistently and cost £1000 each to replace.

SCULPTOR	William McMillan (1887-1977)
INSTALLED	1939
LOCATION	East Fountain, Trafalgar Square, WC2
LATITUDE & LONGITUDE	51.508115, -0.127722

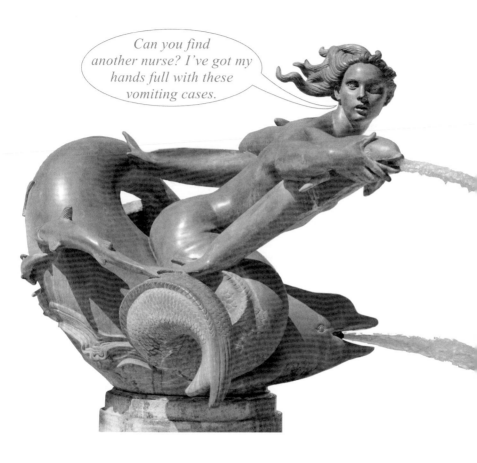

36

Merman

This statue in Trafalgar Square's West Fountain is the creation of Sir Charles Wheeler, the first sculptor to hold the Presidency of the Royal Academy (from 1956 to 1966). Classified as unfit for active service during World War I, Wheeler instead modelled artificial limbs for war amputees.

* * *

The West Fountain is a memorial to Lord Jellicoe (1859-1935), commander of the Grand Fleet at the Battle of Jutland. He was later appointed First Sea Lord, but was removed at the end of 1917 for declaring that nothing could be done to defeat the German U-boats. He also served as the Governor-General of New Zealand in the early 1920s.

SCULPTOR	Sir Charles Wheeler
INSTALLED	1948
LOCATION	West Fountain, Trafalgar Square, WC2
LATITUDE & LONGITUDE	51.507998, -0.128441

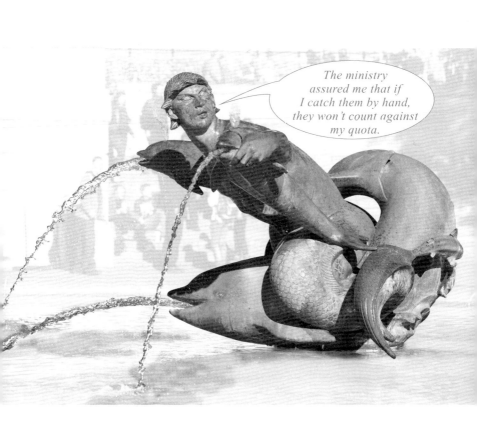

King Charles I (1600-1649)

Charles Stuart was a religious man in a very religious age. Coming to the throne in 1625, he found himself in disagreement with many leading citizens and with Parliament. Believing in the 'Divine Right of Kings', he was confident there was no need to heed other men's views, since his own were supplied by God. The result was the English Civil War.

The victorious Parliamentarians, led by Oliver Cromwell, tried and executed Charles in 1649, passed an act forbidding the proclaiming of another monarch and formally abolished the office of King. And so things remained for 11 years until the Restoration of the Monarchy and the crowning of King Charles II in 1661.

* * *

This is the oldest statue in Trafalgar Square and first statue of an English king on horseback (it was designed to make the small monarch look more imposing). When the civil war broke out the statue had not yet been erected. It was sold by Parliament after the war to a metalsmith called John Rivet of Holborn, with instructions to break it down for scrap metal. Rivet, however, hid the statue. It was later bought by Charles II, who had it installed on the site of the original Charing Cross in 1675.

Today the statue has an unexpected additional role, marking the spot from which all 'distances from London' are measured.

SCULPTOR	Hubert Le Sueur (1580-1658)
INSTALLED	1675
LOCATION	North end of Whitehall, Trafalgar Square, WC1
LATITUDE & LONGITUDE	51.507341, -0.127688

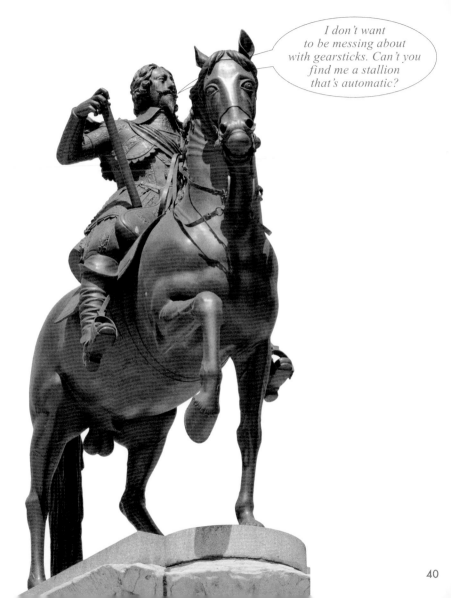

40

Sir Charles Napier (1782-1853)

A general of the British Empire and the British Army's Commander-in-Chief in India, Sir Charles Napier earned his spurs serving in the Napoleonic Wars. He was wounded and left for dead at the Battle of Corunna (1809), then had two horses shot from under him at the battle on the river Coa (1810).

At the age of 60, Napier was appointed Major General commanding the Indian Army. He went to Sindh Province, in what is now Pakistan, to quell rebellions of Muslim rulers hostile to the British Empire. He succeeded in conquering the whole province, greatly exceeding his mandate. He was reported to have sent his superiors the pithy message, "Peccavi" – Latin for "I have sinned", a pun on "I have Sindh". The pun appeared beneath a caricature of Napier in an 1844 edition of *Punch* magazine. In reality, the true author of the pun was Catherine Winkworth, an English girl in her teens, who submitted it to *Punch*, which then published it as fact. Napier, however, defended his conquest of Sindh with the comment: "If this was a piece of rascality, it was a noble piece of rascality!"

* * *

When the sculpture was unveiled to the public in 1856, *The Art Journal* wrote: "The slightest attention to natural form and movement is all that is necessary for the condemnation of the statue of Gen Napier, in Trafalgar Sq, as perhaps the worst piece of sculpture in England. The moral and relative worthlessness of the work exceeds tenfold its formal imperfection."

SCULPTOR	George Gamon Adams (1821-1898)
INSTALLED	1856
LOCATION	Trafalgar Square, WC2
LATITUDE & LONGITUDE	51.507671, -0.12835

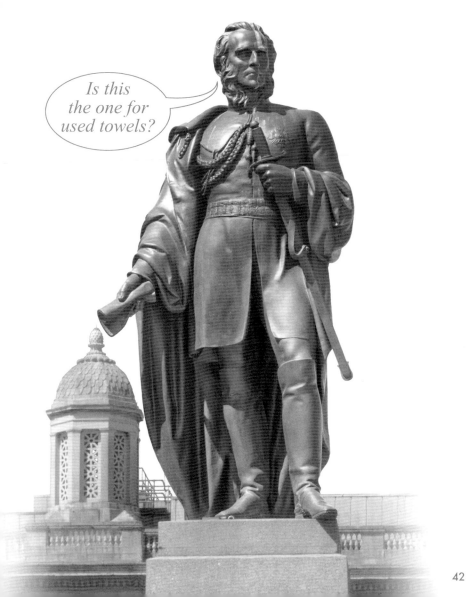

42

James II (1633-1701)

King of England and Ireland and King of Scotland (as James VII) for just three years (1685-88), James II was the last Roman Catholic monarch to sit upon the English throne and one of the most unpopular. He was dubbed 'the Be-shitten' by the English and 'Dismal Jimmy' by the Scots.

James was the younger brother of Charles II. Where Charles was charming, James was arrogant – although both shared an enthusiasm for adulterous affairs.

Given the titles of Duke of York and Albany, James took office as Lord High Admiral and commanded the Royal Navy in wars against the Dutch. When American territory was captured from the Dutch, King Charles II granted it to his brother, James. As a result, Fort Orange was given the name of James's Scottish title, Albany, and the port of New Amsterdam was renamed after James's other title and became New York.

Charles died childless, so James came to the throne. Distrusting his Catholic inclinations, a group of British nobles invited Prince William of Orange (in the Netherlands) to invade and save the Protestant religion. William was married to James's daughter, Mary, so the Royal succession was preserved as long as she became Queen.

The invasion, known as the 'Glorious Revolution', went ahead without conflict. James fled and with French assistance tried to raise an army in Ireland, but was defeated at the Battle of Boyne by his son-in-law, now William III. He lived his final years in exile in a French palace offered by his cousin, King Louis XIV.

* * *

This statue was erected in the Privy Gardens at Whitehall Palace (which no longer exists) in 1685. Stored in a box during World War II at Aldwych underground, it was installed in its current position outside the National Gallery in 1948. A photograph taken in 1988 shows the figure holding a baton in its right hand – but it is not there now.

SCULPTOR	Grinling Gibbons (1648-1721)
INSTALLED	1948
LOCATION	North side of National Gallery, Trafalgar Square, WC1
LATITUDE & LONGITUDE	51.508495, -0.128886

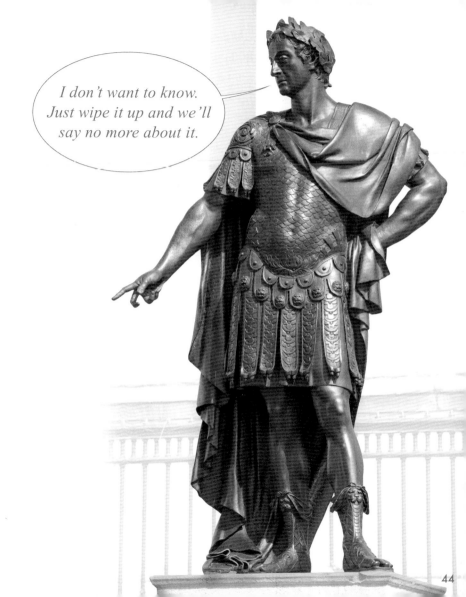

Lord Nelson (1758-1805)

Despite life-long problems with sea-sickness, Horatio Nelson was a celebrated naval leader who delivered the British people from the fear they had endured for years – invasion by the bogeyman Napoleon Bonaparte.

In 1798, Nelson shattered Napoleon's plan to invade Egypt by overcoming the French fleet at the Battle of the Nile. The same year, he defeated the fleet of Napoleon's allies, the Danes, at the Battle of Copenhagen. Most famously, he destroyed Napoleon's Franco-Spanish fleet, which was preparing to enter the English Channel and invade Britain, at the Battle of Trafalgar in 1805.

Nelson's passionate love affair with Lady Emma Hamilton, wife of Sir William Hamilton, the British Ambassador to Naples, both tititlated and scandalised society, but did not seem to interrupt his friendship and business partnership with her husband. Lady Hamilton had two children by Nelson. One daughter survived and was named Horatia.

Nelson went to sea at the age of 12, became both a captain and a husband at the age of 21, lost the sight of his right eye at the siege of Calvi, Corsica in 1794, lost an arm in an attack on a Spanish treasure ship in 1797, and lost his life at the Battle of Trafalgar when he was 47. The bullet that killed him is in the Royal Collection at Windsor Castle.

He never wore an eye patch and was almost certainly kissed by Thomas Hardy, captain of Nelson's flagship HMS *Victory*, as he lay on his death-bed.

* * *

Measured from the pavement to the top of Nelson's hat, the monument in Trafalgar Square is 51.659 metres high. The cost of construction was around £47,000 at mid-19th century prices. Edward Hodges Bailey, who sculpted the white marble statue, was declared bankrupt twice and died penniless. The rope in the sculpture is a traditional symbol, used by artists to signify a mariner.

SCULPTOR	Edward Hodges Baily (1788-1867)
INSTALLED	1843
LOCATION	Trafalgar Square, WC1
LATITUDE & LONGITUDE	51.507831, -0.12795

46

Florence Nightingale (1820-1910)

An innovator in the fields of nursing and statistics, Florence Nightingale came to public attention when, "called by God", she travelled to Turkey in 1854 to nurse the sick and wounded in the Crimean War.

Working at a hospital in Scutari – where she earned iconic status as 'the Lady with the Lamp' – she was appalled by the standard of care: medicines were in short supply, food and hygiene were poor, and infections were common and often fatal. During that first winter 4,700 died; nine tenths of them from diseases and one tenth from war wounds. She brought about dramatic improvements to nutrition, hygiene and ventilation, despite repeated attempts by the British War Office to block her activities.

Returning to England, she suffered from constant bouts of illness and depression, working mainly from her bed for the next fifty years. Despite this, she produced more than 14,000 letters and over 200 books, reports and pamphlets. Politicians and planners visited her bedside for advice.

Florence was a pioneer in the graphic representation of statistics, developing her own elaborations of the 'pie chart'. In 1859 she was elected the first woman member of the Royal Statistical Society, and later became an honorary member of the American Statistical Society.

Dismissing her celebrity as "all that ministering angel nonsense", Florence's only wish at the end of her life was "to be forgotten". But she is remembered for paving the way for free healthcare and the National Health Service, established 40 years after her death. She was also the first woman to appear on a British banknote, an inspiration for the International Red Cross… and had a pet owl called Athena.

* * *

Part of the Crimean War Memorial, this monument by British sculptor Arthur George Walker is remarkable for not only commemorating the servicemen who lost their lives but also the contribution of nurses. The bronze statue stands on a pedestal bearing four bas-reliefs illustrating her diverse roles: carer to the injured; negotiator with politicians and generals; challenger to medical and hospital managers; teacher and inspiration to nurses.

SCULPTOR	Sir Arthur George Walker (1861-1939)
INSTALLED	1914
LOCATION	Waterloo Place, SW1
LATITUDE & LONGITUDE	51.507297, -0.132706

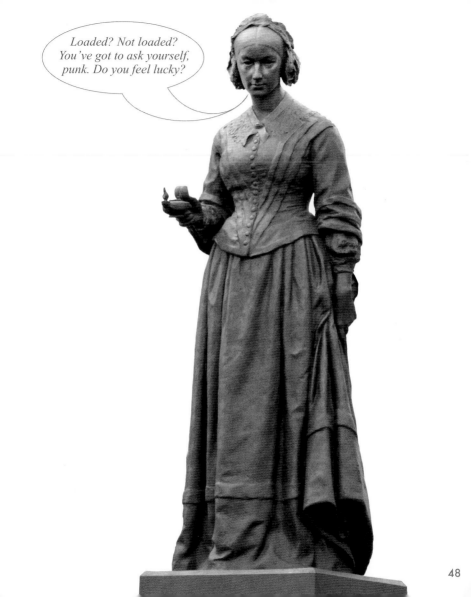

48

Charles de Gaulle (1890-1970)

Charles De Gaulle was a French general and statesman who led the Free French forces during World War II and later became President of France.

Having rejected the June 1940 armistice with Germany, de Gaulle fled to Britain, where he gave a famous radio broadcast via the BBC encouraging the French to resist the Nazis. Working from an office in Carlton Gardens (near this statue), he galvanised exiled officers to form what was effectively a 'remote' French government.

After the war he briefly became Prime Minister in the French Provisional Government, then founded his own party in 1947. Failing to gain power in 1950, he turned his back on politics. In 1958, when the French armed forces threatened the state in a dispute over the French colony of Algeria, de Gaulle blamed the constitution of the 4th French Republic and was instrumental in drawing up a new one for the 5th Republic. He was elected President of France and held that position until 1969, resigning when his authority was undermined by industrial and student unrest.

De Gaulle's controversial policies were strongly patriotic and independent. Observing that it was hard to govern a country which "had 246 varieties of cheese", he presided over France's acquisition of nuclear weapons, withdrew France from NATO in 1966 and was the driving force behind the European Union, twice vetoing Britain's membership. Such decisions endorsed his contention that: "A man of character finds a special attractiveness in difficulty, since it is only by coming to grips with difficulty that he can realise his potentialities." This from a man who once said (to Winston Churchill) that the French regarded him as the reincarnation of Joan of Arc.

* * *

Measuring 6 foot, 5 inches, this statue bears the soubriquet *La Grande Asperge* ('The Great Asparagus'). It was created by Angela Conner, a former assistant to Barbara Hepworth now renowned for her 'kinetic' sculptures (ones that move).

SCULPTOR	Angela Conner (1935–)
INSTALLED	1993
LOCATION	Carlton Gardens, Westminster, SW1
LATITUDE & LONGITUDE	51.505651, -0,134226

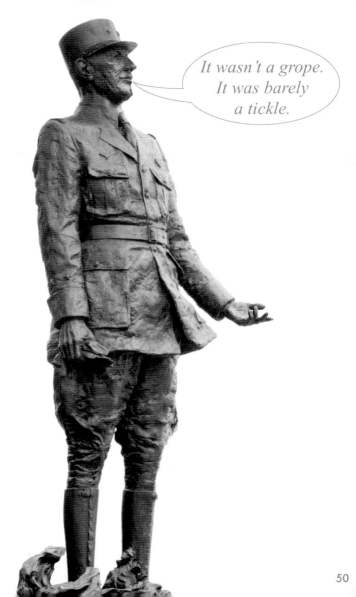

50

Anteros

The Shaftesbury Memorial, one of the first statues to be cast in aluminium, is often mistakenly referred to as Eros. In fact, it portrays Anteros, god of requited love and punisher of those who scorn love, as opposed to his brother Eros, god of one-sided love.

* * *

Anteros commemorates the politician and philanthropist Anthony Ashley-Cooper, the 7th Earl of Shaftesbury (1801-1865), and symbolises his philanthropic love for the poor.

As well as campaigning for the improvement of conditions for 'lunatics', Shaftesbury introduced the 'Ten Hour Act' of 1833, which decreed that children could not be employed in the cotton and woollen industries before they were nine years old, and that people under 18 should not work more than ten hours a day and no more than eight hours on a Saturday. He also fought for better conditions for miners, the cessation of employment of women and children underground, and the abolition of the practice of sending small boys up chimneys to clear the soot.

SCULPTOR	Alfred Gilbert (1854-1934)
INSTALLED	1893
LOCATION	Piccadilly Circus, W1
LATITUDE & LONGITUDE	51.509906, -0.134516

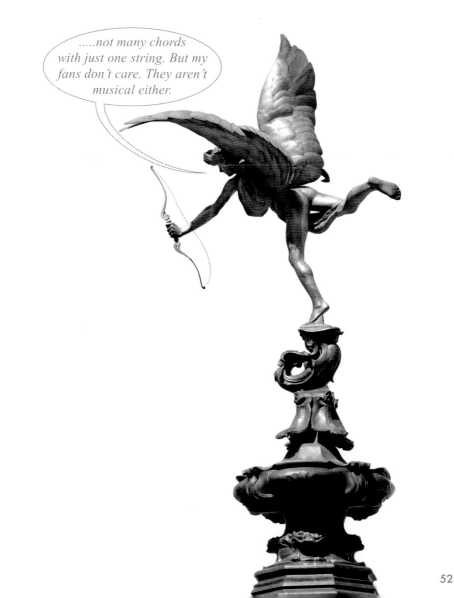

52

Cherub

The fountain in the garden of St James's Church where this cherub stands is a memorial to Julius Salter Elias, Viscount Southwood (1873-1949), and features urns containing both his ashes and those of his wife.

From a poor background, Elias left school at the age of 13 to be a junior among the 20 staff at Odhams Bros. By the end of his life, he had transformed the company into Britain's largest newspaper and printing company with 13,000 employees, but still found time to serve as Chief Whip for the Labour Party in the House of Lords in 1944.

As a dedicated philanthropist, one of his special interests was the children's hospital, now known as Great Ormond Street Hospital – hence the four bronze cherubs, representing children, which distinguish this memorial. The work for the fountain was carried out by deaf and dumb stonemasons, employed by consent of the government to keep the art of stonemasonry alive during the war years.

* * *

This statue was sculpted by Londoner Alfred F. Hardiman. His studies were interrupted by World War I, during which he served as a draughtsman for the Royal Flying Corps. In World War II his house suffered a direct hit from a bomb and the studio where he worked was also destroyed. Thus he was probably psychologically ready to fulfil Elias's bequest to transform the bomb-damaged garden of St James's Church into a haven of peace.

SCULPTOR	Alfred F Hardiman (1891-1949)
INSTALLED	1949
LOCATION	St James's Church, Piccadilly, W1
LATITUDE & LONGITUDE	51.508718, -0.13701

How do you say they do it? With just one glove? Well, what would Americans know about baseball?

54

Allies

This sculpture of Winston Churchill (1874-1965) and Franklin D. Roosevelt (1882-1945) was unveiled in 1995 by the Bond Street Association to mark 50 years of peace since the end of World War II.

Roosevelt was the 32nd President of the USA and Churchill was Prime Minister of the UK during WWII, for which the two countries were allied. Coincidentally, Churchill's mother was American and Roosevelt and Churchill were distantly related.

When forming an alliance against Hitler at the outset of WWII, they were markedly different in personality and intent. Churchill was transparent and impulsive, desperate to bring the United States into the war. Roosevelt was secretive and calculating, determined to keep the United States out of it.

But as the conflict deepened, an "epic friendship" developed between the two leaders, based on mutual respect and a willingness to understand their often contrary interests. Between 1941 and 1945 they met nine times around the world, constantly writing or cabling each other between visits. As a result, their relationship remained close even when they clashed.

At the end of the war, after failing to reach agreement over how to structure the peace, Churchill wrote to Roosevelt (who died a week later): "I regard the matter as closed and to prove my sincerity I will use one of my very few Latin quotations, 'Amantium irae amoris integratio est'." Translation: "Lovers' quarrels always go with true love."

* * *

Allies was created by Lawrence Holofcener, who, aptly enough, holds dual American and British nationality. Credited in his biography as a poet, lyricist, playwright, artist, novelist, actor, director and sculptor, he exhibited for the first time in 1979, when he was 53, but has since completed many commissions.

SCULPTOR	Lawrence Holofcener (1926–)
INSTALLED	1995
LOCATION	Bond Street, W1
LATITUDE & LONGITUDE	51.510446, -0.142617

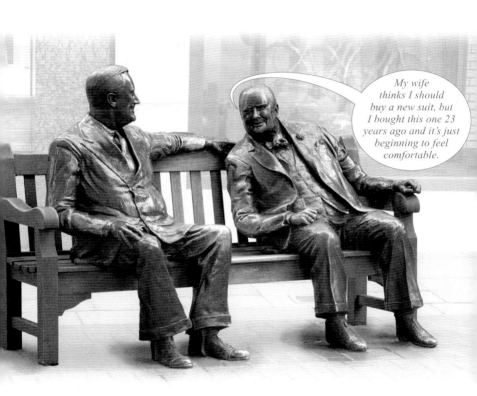

Manufacture

One of four allegorical bronze figures on the outer edges of the Queen Victoria Memorial in front of Buckingham Palace, this statue of blacksmith and lion represents 'Manufacture'. The other three represent 'Agriculture', 'Peace' and 'Progress'. All are accompanied by lions.

The Victoria Memorial incorporates 2,300 tons of marble, 800 tons of granite and 70 tons of bronze. The monument is 82 feet (25 metres) high and the statue of Victoria herself is 18 feet (5.5 metres) tall. She sits in the centre, surrounded by a host of allegorical figures.

* * *

The design for the memorial, by architect Sir Aston Webb, was chosen in 1901, when Queen Victoria died after 60 years on the throne. Thomas Brock was selected to execute the sculpture and all of the many figures are his work. After ten years of intensive work, the monument was unveiled in 1911 by King George V and his cousin Kaiser Wilhelm II of Germany.

The story has it that King George V was so thrilled by the memorial when he unveiled it that he called for a sword, asked Brock to kneel and knighted him on the spot. However, the work was not complete – the bronze figures with lions were not completed until 1924, two years after Brock's death.

SCULPTOR	Sir Thomas Brock (1847-1922)
INSTALLED	1924
LOCATION	The Mall, Buckingham Palace, SW1
LATITUDE & LONGITUDE	51.502118, -0.140433

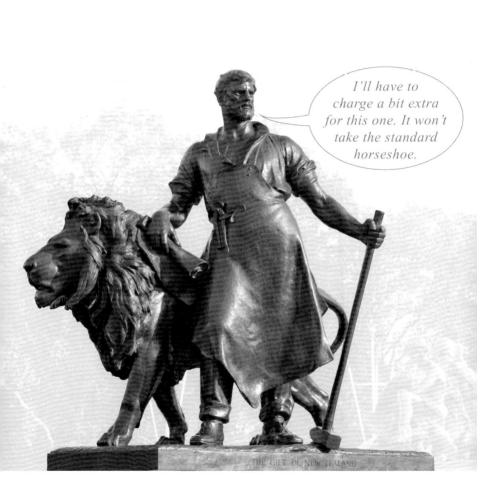

Robert Grosvenor (1767-1845)

Robert Grosvenor, 1st Marquess of Westminster, was a Member of Parliament from 1788 to 1802 and was also appointed a Lord of the Admiralty.

A wealthy aristocrat, he started out as a Tory but changed to the Whig Party when the death of Pitt the Younger signalled an end to the more enlightened policies of 'New Toryism'. He was thus sympathetic to the victims of the Peterloo Massacre (when cavalry charged a huge crowd in Manchester campaigning for political reform); in favour of Catholic Emancipation; and a supporter of Queen Caroline, the figurehead of a movement opposing her unpopular husband King George IV – at whose head Grosvenor is said to have thrown a book.

Grosvenor inherited several country estates, as well as prime land in central London. The developments he and his father made in areas such as Eaton Square, Belgravia and Mayfair formed the basis for the family's present wealth. His descendent Gerald Grosvenor, Duke of Westminster – who commissioned this sculpture – was listed 7th on *The Sunday Times* 2012 Rich List, with an estimated fortune of £7.3 billion.

* * *

The statue's sculptor, Jonathan Wylder, held his first one-man show of paintings when only 16 in Salisbury City Library, whereupon Sir Cecil Beaton became his first patron. He didn't begin sculpting until he was in his thirties, and since then has frequently used ballerinas as his subjects.

SCULPTOR	Jonathan Wilder (1957–)
INSTALLED	1998
LOCATION	Wilton Crescent & Grosvenor Crescent, SW1
LATITUDE & LONGITUDE	51.500381, -0.153793

Quadriga 'Peace'

Otherwise known as 'The Angel of Peace Descending on the Chariot of War', this statue crowning Wellington Arch at Hyde Park Corner features the quadriga (a chariot drawn by four horses abreast) common to triumphal arches in numerous European cities including Berlin, Paris and Rome.

Plans for the arch had many stops and starts involving illustrious names from the art world, but the one eventually built in 1826 by Decimus Burton featured a quadriga on the top. By 1847, demand for yet another monument to the Duke of Wellington, who lived nearby, had led Matthew Cotes Wyatt to create an enormous, 27-foot equestrian statue which replaced the quadriga. Proposals in 1883 to move the arch to ease traffic congestion gave those who disliked Wyatt's statue the ammunition to have it moved to Aldershot, a town with military associations.

* * *

Installed in 1912, the Peace quadriga was sculpted by Adrian Jones, who served as a vet in several army regiments before setting up as an artist in Chelsea. When the Prince of Wales proposed Jones as the sculptor for the quadriga, the art establishment was unimpressed – or possibly envious – as he had only recently begun sculpting and his list of public works was short. However, his previous career as an army vet meant his familiarity with the anatomy of horses was unparalleled. Some 23 years later, the art establishment awarded Jones the gold medal of the Royal Society of Sculptors.

Funds for the sculpture were provided by Lord Mickleham – it is his son who was the model for the driver holding the reins of the chariot.

SCULPTOR	Adrian Jones (1845-1938)
INSTALLED	1912
LOCATION	Apsley Way, Hyde Park Corner, W1
LATITUDE & LONGITUDE	51.502582, –0.150909

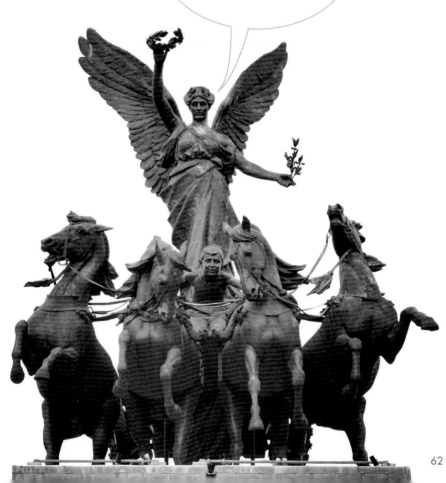

62

The Search For Enlightenment

These two bronze star-gazers outside One Hyde Park, purportedly the world's most expensive residential building, are the creation of Simon Gudgeon. A former solicitor, he didn't start sculpting until he was 40, when he made an impulse purchase of artist's clay. His sculptures reflect his lasting fascination for the natural world, first ignited as a boy growing up on a farm deep in the countryside.

It was contemplation of the cosmos that inspired this creation, as the sculptor himself describes: "I stood on a 240 million year old mountain in Africa and watched the 4.6 billion year old sun descend below the horizon. As the light diminished the 200 billion stars in the Milky Way began to glow in the night sky. Our galaxy extends for 100,000 light years and is part of a Universe that is 93 billion light years across. The Universe is over 10 billion years old and consists of hundreds of billions of galaxies. It was at that moment I began to grasp the narrowness of consciousness, the vastness of time and the transience of humanity."

* * *

One wonders quite what the figures in Gudgeon's sculpture would make of the inhabitants of One Hyde Park, the building designed by Richard Rogers outside of which they stand. According to the journalist Nicholas Shaxson, 76 of the 80 apartments had been sold by January 2013 for a total of $2.7 billion, "but, of these, only 12 were registered in the names of warm-blooded humans". The remaining 64 were held in the names of unfamiliar corporations, many registered in well-known offshore tax havens.

SCULPTOR	Simon Gudgeon (1958–)
INSTALLED	2012
LOCATION	One Hyde Park, Knightsbridge, SW1
LATITUDE & LONGITUDE	51.502385, -0.160897

Rush of Green

Sited at Edinburgh Gate on the edge of Hyde Park, this is the last work by the celebrated sculptor Sir Jacob Epstein, who was still working on it the evening before he died, in August 1959. The work depicts a family and its dog rushing towards the green of Hyde Park, urged on by the god Pan, playing his pipes.

* * *

Jacob Epstein was raised in New York, one of eight children born to Orthodox Jews from Poland. By the time he died at the age of 78, he'd become an Englishman, knighted by Queen Elizabeth II and living across the street from Winston Churchill.

Many of his works were reviled – whether because of their modern abstraction, their priapic nudity or the plain xenophobia of their critics – yet they were frequently acclaimed as well.

Visiting his sculpture for Oscar Wilde's tomb in Père Lachaise cemetery in Paris, Epstein was horrified to discover that "the sex parts of the figure had been swaddled in plaster" and that "I must either castrate or fig leaf the monument!" Many years later, he carved an 86-inch-tall Adam from alabaster, endowing the nude figure with equipment large enough to justify his standing as the father of mankind. Whenever Queen Elizabeth II visits her cousin, who owns the sculpture, she is never photographed near this work.

Despite continuing to live with his first wife Margaret, Epstein had a number of relationships with other women that brought him his five children. Margaret generally tolerated these relationships – even to the extent of bringing up his first and last child – but her tolerance did not extend to Kathleen Garman, the mother of his three middle children and eventual second wife. In 1923, Margaret shot and wounded Kathleen in the shoulder.

SCULPTOR	Sir Jacob Epstein (1880-1959)
INSTALLED	2010/11
LOCATION	Edinburgh Gate, Hyde Park, London SW1
LATITUDE & LONGITUDE	51.502287, -0.162137

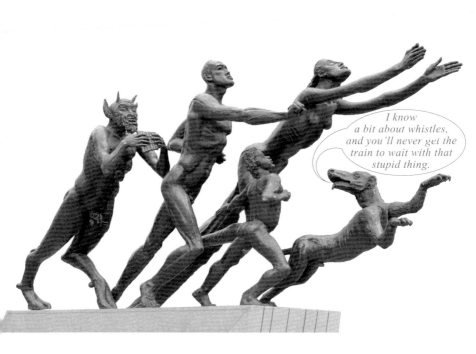

Peter Pan

This statue of the writer J.M. Barrie's famous fictional character was raised in secret during the night and 'magically' appeared on 1 May 1912.

There was no prior publicity, but on the day of the statue's arrival Barrie placed the following announcement in *The Times*: "There is a surprise in store for the children who go to Kensington Gardens to feed the ducks in the Serpentine this morning. Down by the little bay on the south-western side of the tail of the Serpentine they will find a May-day gift by Mr J.M. Barrie, a figure of Peter Pan blowing his pipe on the stump of a tree, with fairies and mice and squirrels all around. It is the work of Sir George Frampton, and the bronze figure of the boy who would never grow up is delightfully conceived."

* * *

As well as commissioning the statue himself, Barrie also chose its location, saying it was Peter Pan's actual landing point from Never-Never Land. Nor did he get permission to put it in Kensington Gardens, prompting questions in the House of Commons about whether an author should be permitted to promote his own work by placing a statue of one of his characters in a public park. However, the statue proved so popular with the public that it remained in place.

Another copy of this sculpture was unveiled in Sefton Park, Liverpool, in 1928, although its creator, Sir George Frampton, died a few weeks before the ceremony. Further castings were installed in St John's, Newfoundland; Camden, New Jersey; Brussels, Belgium; Perth, Australia and Toronto, Canada.

SCULPTOR	Sir George Frampton (1868-1928)
INSTALLED	1912
LOCATION	Kensington Gardens, W2
LATITUDE & LONGITUDE	51.508903, -0.17615

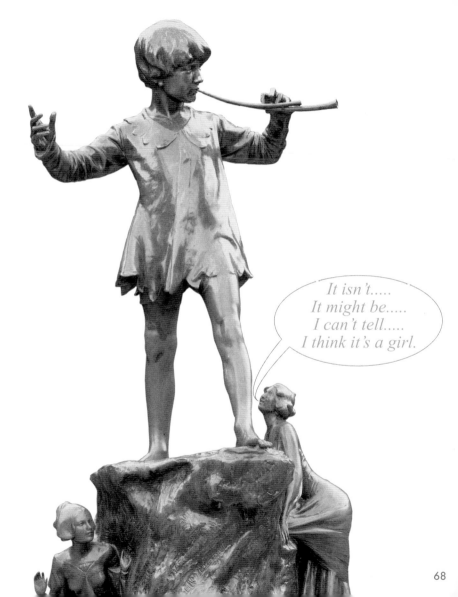

Awakening

This sculpture by Gilbert Ledward stands in Roper's Garden, named after Sir Thomas More's daughter, Mary Roper. This small, sunken garden also contains the bas-relief 'Woman Taking Off Her Dress' by Jacob Epstein (*see pp 63-64*) who had a studio overlooking the garden from 1909-1941. The garden was bombed in 1941.

* * *

Gilbert Ledward was born in Chelsea, son of a sculptor, but he was only two when his father died. When he was 13, his mother moved the family to Germany. Back in London four years later, he attended Goldsmiths College and The Royal Academy, winning medals and scholarships, but his ensuing travels were cut short by the outbreak of World War I. He served well and was mentioned in despatches before being recalled to England to work as a war artist for the Ministry of Information. He later produced a great number of war monuments, including the Guards Memorial in St James's Park.

SCULPTOR	Gilbert Ledward (1888-1960)
INSTALLED	1923
LOCATION	Roper's Garden, Chelsea Embankment, SW3
LATITUDE & LONGITUDE	51.482685, -0.171806

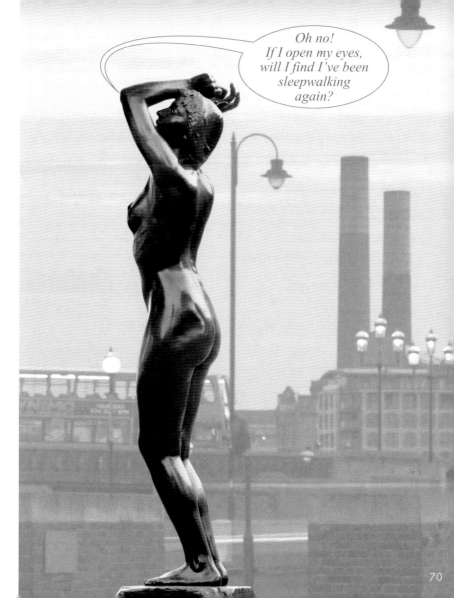

70

Atalanta

This nude by Francis Derwent Wood is of Atalanta, a character from Greek mythology. Abandoned in the woods, she was brought up by a bear and became a successful and athletic huntress – so much so that she refused to marry her suitor Hippomenes unless he could beat her in a running race. Venus, goddess of Love, appeared to Hippomenes and gave him three golden apples. During the race he rolled the apples on the ground, distracting Atalanta long enough to win the contest. They duly married and were turned into lions.

The original 'Atalanta', sculpted in marble in 1909, is now held by the Manchester Art Gallery. After Wood's death, members of Chelsea Arts Club and friends had a bronze cast made from the original and placed it in his memory by Albert Bridge in 1929. Thieves cut the statue off at the ankles in 1991, leaving just a pair of feet on the plinth. The members of Chelsea Arts Club joined forces once again, replacing a new cast on the plinth, this time with security lighting and a camera.

* * *

Francis Derwent Wood assisted Thomas Brock in creating the Queen Victoria Memorial (*see pages 55-56*) and was appointed Professor of Sculpture at the Royal College of Art in 1918.

Too old at 41 to enlist at the onset of World War I, Wood volunteered in the Medical Corps. Exposure to the horrific facial injuries inflicted on the troops led him to open the Masks for Facial Disfigurement Department, a special clinic at the Third London General Hospital in Wandsworth. Instead of using conventional rubber masks, Wood constructed masks of thin metal, sculpted to match the portraits of the men before their injuries. Painstakingly crafted over many weeks, these masks did much to restore the shattered confidence of the soldiers and ease their return to family life.

SCULPTOR	Francis Derwent Wood (1871-1926)
INSTALLED	1929/1991
LOCATION	Chelsea Embankment, near Albert Bridge, SW3
LATITUDE & LONGITUDE	51.482759, -0.170614

It's just a slight itch on my chest here, doctor, but I thought you might want to give me an all-over check-up while you have the opportunity.

Sir Isaac Newton (1643-1727)

Isaac Newton originated the scientific understanding of gravity, as well as making formidable leaps in the study of the nature of light, physics (including the laws of motion), mathematics and astronomy – mostly before he was 25. He was the first scientist to be knighted for his work, by Queen Anne in 1705.

While laying the foundations for the future of science, Newton also studied alchemy in a lifelong bid to find the 'philosopher's stone', which would turn base metal into gold and possibly yield the 'elixir of life'. A 1979 examination identified extraordinary amounts of mercury in Newton's hair, probably due to his alchemy experiments. He also studied Biblical numbers in an attempt to recover the 'secret knowledge of the ancients'. Considering himself specially chosen by God to interpret the Bible's predictions, he concluded the world would end no sooner than 2060.

Born prematurely, Newton had an unhappy childhood, developing a stutter and a compulsion for making lists, one of which recorded all the sins he felt he had committed up until the age of 19, including a threat to burn his mother and father. These formative experiences may partly account for the nervous breakdowns he suffered in 1678 and 1693, although his exposure to mercury cannot have helped.

* * *

Sir Eduardo Paolozzi's sculpture takes its overall form from a 1795 watercolour entitled 'Newton' by the mystical poet and artist William Blake.

Paolozzi was born in Scotland, the son of Italian immigrants who ran an ice-cream business. At 16 he was interned as 'an enemy alien', while his father and uncle, sent to Canada for the same reason, died when their ship was sunk by the Germans. A prolific artist with 381 works held by the Tate Gallery alone, he was a pioneering exponent of what came to be known as Pop Art.

SCULPTOR	Sir Eduardo Paolozzi (1924-2005)
INSTALLED	1995
LOCATION	British Library Forecourt, Euston Road, NW1
LATITUDE & LONGITUDE	51.529038, -0.127625

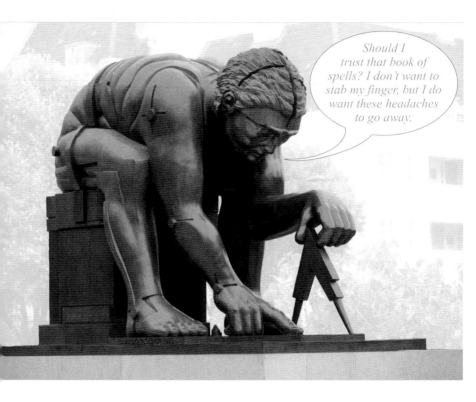

Shepherdess

Also sometimes referred to as 'The Goatherd's Daughter', this rustic figure is located in the 'secret garden' of St John's Lodge, just north-east of the inner circle in Regent's Park. The lodge is owned by the Sultan of Brunei, but the garden – though not easily found – is open to the public.

* * *

Created by C.L. Hartwell, a devotee of the New Sculpture movement, the statue is dedicated to "all the protectors of the defenceless" in honour of Harold and Gertrude Baillie Weaver. Both were steadfast supporters of the Suffragette movement and ardent animal welfare campaigners.

SCULPTOR	Charles Leonard Hartwell (1873-1951)
INSTALLED	1931 (moved within the garden in 1994)
LOCATION	St John's Lodge Gardens, Regent's Park, NW1
LATITUDE & LONGITUDE	51.5294, -0.1515

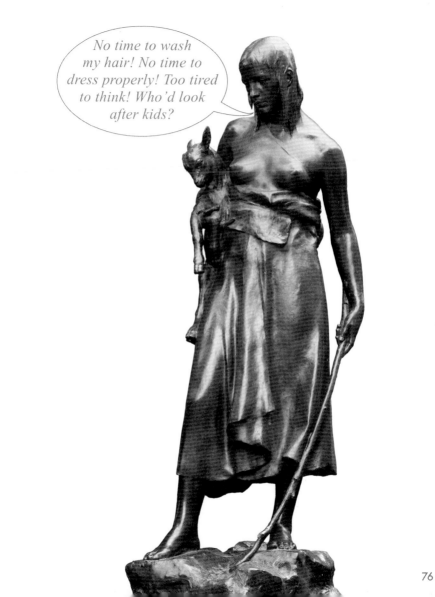

Lost Bow

This putto (chubby male child) in Queen Mary's Gardens, Regent's Park, is thought to have been commissioned by Sir Sigismund Goetze (1866-1939), the wealthy painter, who lived nearby in Nuffield Lodge. It was donated in 1939 by his widow, Constance, who continued commissioning sculpture and presenting it to London parks through her 'Constance Fund'.

The sculpture is the work of Albert Hodge, who was born on Islay and originally trained as an architect before his skill in modelling led him to become a sculptor. The statue is now a listed building, according to English Heritage. The listing reads: "The vulture gazes backwards towards the putto whose raised hand holds an arrow with which to stab the bird." However, the arrow is currently missing and leaves the putto making a strange, empty gesture.

* * *

Queen Mary's Gardens, named after the wife of King George V, opened to the general public in 1932. Its famous rose garden contains London's largest collection of roses (approximately 12,000), with 85 single variety beds on display.

SCULPTOR	Albert Hodge (1875-1918)
INSTALLED	1939
LOCATION	St Mary's Gardens, Regent's Park, NW1
LATITUDE & LONGITUDE	51.527387, -0.152074

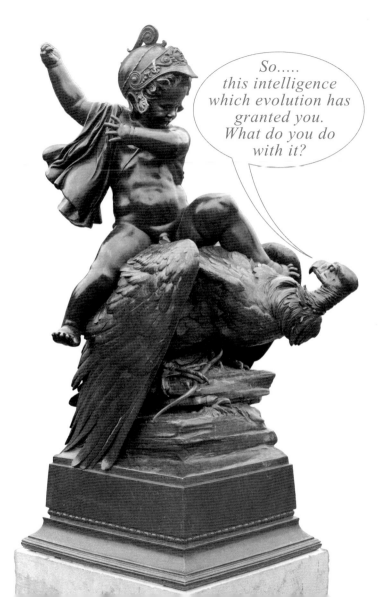

78

Mighty Hunter

This putto is a companion piece to the 'Lost Bow' sculpture of the previous page. It therefore shares the same details: sculpted by Albert Hodge, donated by Constance Goetze, located in St Mary's Gardens, and now a listed building.

SCULPTOR	Albert Hodge (1875-1918)
INSTALLED	1939
LOCATION	St Mary's Gardens, Regent's Park, NW1
LATITUDE & LONGITUDE	51.527387, -0.152074

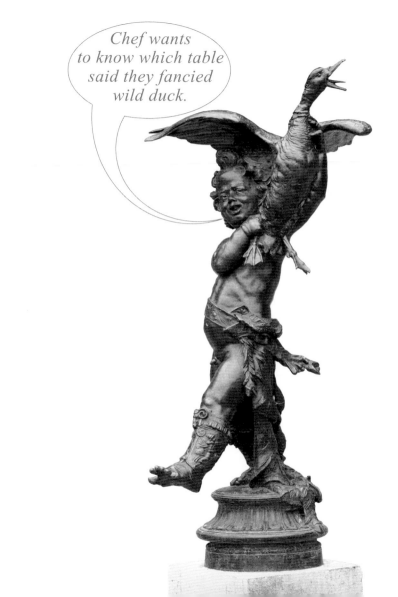

Triton & Mermaids

In ancient Greek mythology Triton was the son of Poseidon (Neptune to the Romans), god of the sea. He blew his conch shell like a trumpet to raise storms or calm the seas according to his father's instructions. Its sound, when loudly blown, apparently put giants to flight.

* * *

Like 'Lost Bow' and 'Mighty Hunter', this sculpture by William McMillan (*see pp 33-34*), which stands in Queen Mary's Garden in Regent's Park, was also donated by Constance, widow of Sigismund Goetze.

SCULPTOR	William McMillan (1887-1977)
INSTALLED	1950
LOCATION	Queen Mary's Garden, Regent's Park, NW1
LATITUDE & LONGITUDE	51.528844, -0.15337

St George

St George is the Patron Saint of England – and, incidentally, many other states and cities. Sculpted by CL. Hartwell (*see pp 73-74*), this striking version of the celebrated dragon-slayer is a memorial to "the men and women of Saint Mary-Le-Bone who by their service and sacrifice for king and country freely played their part" in both World Wars.

* * *

It is thought that Saint George was born to a Greek Christian noble family in Lyda (now in Israel) during the third century. As a young man he went to the imperial city of Nicomedia, where he was welcomed into the Roman Army by Emperor Diocletian, who had known his father. He rose to become a tribune.

In AD 302, Diocletian issued an edict that all Christians in the army were to be arrested and all the others were to make a sacrifice to the Roman gods. George went to Diocletian, and in front of other soldiers, declared his Christianity and denounced the edict. Not wanting to lose a favourite soldier, Diocletian tried hard to convert George with enormous bribes, followed by torture. George refused to convert, gave all his property to the poor and was executed.

The earliest record of the dragon-slaying legend dates from the 11th century. The town of Silene had a lake where a dragon lived, poisoning the countryside. To appease the dragon the people fed it sheep, but when those ran out they began to feed it their children. Eventually, the king's daughter was chosen in the lottery and was waiting to be eaten when St George rode by. He wounded the dragon, made a lead out of the princess's girdle and led the beast into town. When the citizens had agreed to become Christians, St George finally slew the dragon.

SCULPTOR	Charles Leonard Hartwell (1873-1951)
INSTALLED	1936
LOCATION	Junction of Wellington Road and Park Road, NW8
LATITUDE & LONGITUDE	51.530132, -0.167845

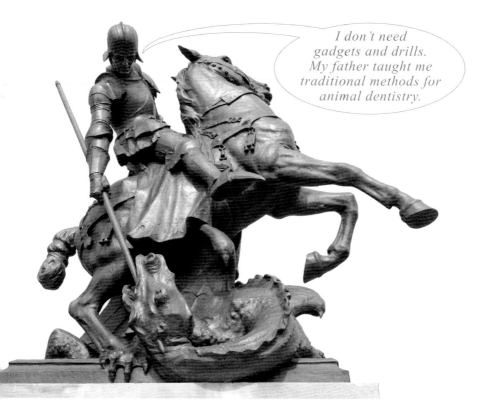

Sigmund Freud (1856-1939)

The founder of psychoanalysis, Sigmund Schlomo Freud was born into a Jewish family in Freiberg, Moravia. He became a neurologist in the psychiatric clinic at Vienna General Hospital before setting up in private practice.

Through psychoanalysis, Freud sought to understand the mind by studying the effects of previous experiences, hidden emotions and unconscious processes normally considered too embarrassing or upsetting to discuss. Some found this disgusting. When the Nazis publicly burned Freud's books in 1934, he responded by saying: "What progress we are making. In the Middle Ages they would have burned me. Now, they are content with burning my books."

Reluctantly, Freud fled to England in June 1938 and lived with his family in Maresfield Gardens, Hampstead, a short distance from the location of this statue. By September the following year, the cancer of the jaw and mouth which he'd endured for 15 years became too painful to bear. He committed suicide with the aid of his doctor, Max Schur, and his daughter Anna.

* * *

Freud was not keen to be portrayed, so it was a coup for the sculptor Oscar Nemon when he was asked to make this work on Freud's 75th birthday in 1931. The plaster statue was not cast in bronze until a worldwide appeal amongst psychiatrists raised the funds. First installed in 1970 outside Swiss Cottage Library, it now stands within the grounds of The Tavistock Centre, which provides mental health services.

Nemon himself was born in Osijek, Croatia. Like Freud, he fled to England in 1938 to escape Nazism (the rest of his family died at Auschwitz). He became a British citizen, sculpting for celebrated patrons including Sir Winston Churchill and the Queen, who also became his personal friends. He was working on a relief of Princess Diana for the Wedgewood Company when he suffered a fatal heart attack.

SCULPTOR	Oscar Nemon (1906-1985)
INSTALLED	1998
LOCATION	Tavistock Centre, Belsize Lane, NW3
LATITUDE & LONGITUDE	51.546162, -0.175645

La Déliverance

Sculpted by the pacifist Emile Oscar Guillaume, La Déliverance is an allegorical commemoration of the victory of France and her Allies over Germany in World War I – in particular, the First Battle of the Marne (September 1914), which halted the German army's initial thrust through France and thus prevented Paris from falling into enemy hands.

Eleven copies were initially offered in 1919 to French and Belgian cities occupied or destroyed by the Germans. In Lille, controversy regarding the nudity of the subject resulted in it being removed and offered to Nantes instead, where it remains.

The original of the statue, exhibited at the Paris Salon in 1920, was seen and admired by Viscount Rothermere (1868-1940), proprietor of the *Daily Mail* newspaper. He commissioned this copy, chose its location, which he often passed when visiting his mother, and presented it to the Finchley Urban District Council in her memory.

* * *

The statue was unveiled on 20 October 1927 by David Lloyd George (*see pp 27-28*), before a crowd of over 8,000. Known locally as 'The Naked Lady', La Déliverance is not an official Finchley war memorial, it is listed as No. 3129 on the Imperial War Museum's *National Inventory of War Memorials*.

SCULPTOR	Emile Oscar Guillaume (1867-1942)
INSTALLED	1927
LOCATION	Regents Park Road & Charter Way, Finchley, N3
LATITUDE & LONGITUDE	51.590904, -0.199999

Notes